HEAVY

AND

INTENSE

ELIZABETH CHALLINOR

DISTR-

-ACTED

HEAVY AND
INTENSE

TRYING TO

QUIT
EVERY
THING

RUINING

SWITCH
THE
FUCKING
TAP
OFF

ABSO LUTE FOOL

BREATHE THROUGH

NOT

PREPARED

TO

HI

BER

NAT

ING

WHAT IS WRONG?

SHITTY CHANNEL 4 VERSION OF BAKE OFF

REWATCHING

IN APPRO PRI ATE

PEOPLE
ARE
GOING
TO

HARAMBE

GETS
AUTOCORRECTED

WHY
WOULD

MASTER

AND

MARGARITA

LAST

NIGHT

CUTTING
CHEESECAKES

DO
REGULARLY

JUST

DON'T

KNOW

HATE

EVERY

THING

SO ANGRY
THAT

RELY ON OTHER PEOPLE

DOG ATE MY WEETABIX

INTENSE

GENUINELY

CO MP LA IN

IGNORE

EVERYONE

SO

SHIT

RUNNING OUT

OF THINGS

CHICKEN
OR
JÜRGEN
KLOPP

FROM

LIVERPOOL

SO
FED UP,

LEAVING

MORE

POETIC,

BUT

RECOGNISE

SO

DIS

GUS

TING

ABSOLUTE

**SKIP
FORWARD
TO
SWEET
DREAMS,
TN**

NICE
AND
SMILEY

NERVOUS

SHARING

PUNCH THEM IN THE FACE

WOULD PHONE

TO BE OVER

ACCIDEN

TALLY

JUST
WANT
TO
STOP

HOW

I

MET

YOUR

MOTHER

REST OF
THE DAY

REALLY

COOL

INSTALLATION

LOUDER

THAN

NECESSARY

LOCK

HER

OUTSIDE

BUY
PAOLO
NUTINI
TICKETS
AND
LEAVE

WORST SUMMER

IN
A
BIL
IT
Y

LIFELONG GOAL OF HAVING 101 DALMATIANS

A
NAP
INSTEAD

REGRET
IT

GUILTY

AN
YM
OR
E

DON'T
WANT
TO,
BUT

BAKE

OFF

DON'T
KNOW
WHO

SINCERE

COMPLAINTS

FED
UP
OF
TRYING
TO

ENTIRE
2016
RIO
OLYMPICS

PROPER
STRESSING

SIMMER

DOWN

EAT
SOME
SPAGHETTI
HOOPS

NOT OVER

EXHIBITING

LEAVE THE COUNTRY

SO

LET'S

PUT

A

PIN

IN

WASN'T GOING

RE

COG

NISE

COMFORTABLE

TALKING

ABOUT

BORING RACE
ANYWAY

CLEARLY

HASN'T

HAPPENED

YET

HAVE

A

GRUDGE

AGAINST

DECI DED TO DO THIS

STEREOTYPICAL

SHITTY

SENTENCES

IN

NEON

LIGHTS

PEOPLE
TELLING

TOO
DISTRACTED
BY

BUYING FALAFEL

CAN

GO

AWAY

READY TO KICK OFF AT

BEAR

NECESSITIES

OR

BARE

NECESSITIES

SO
SELF
CENTERED

BITCHY LONDON ART SCHOOLS

NEVER

GAVE

**PROBABLY
DISLIKE
THEM**

CURL

UP

FAR

TOO

MANY

CAN'T

SPELL

REALLY

BASIC

COMPLETE
LY
INAPPROP
RIATE
TIME

STRUGGLING

TO

THINK

PHSYICALL Y CAN'T BREATHE

NAP SO BAD

ALWAYS
SAYS
"DROP
ME
A
LINE"

NEIGHBOUR'S PLUM TREE

BOTTLE
AT AN
ARTIST

DEFNITELY
AND FATHER

NO

FORM

OF

CONTINUITY

THERE'S
NO ROOM

**BACK
FOR A
WHILE**

UNIVERSITY

IN THE

WINTER

DECIDED
TO DO
THIS

AN

YT

HI

NG

TAYLOR
SWIFT
PISSES

SERIOUSLY WISHES

CHICKEN

NUGGETS

EXIST

STUPID

PUNS

FOR

NO

REASON

REALLY

WANTED

IT

**GOOD
NIGHT'S
SLEEP**

ANYTHING
TO COMPLAIN
ABOUT

NEW CONTEMPORAR IES ONLY EVER FULL OF

FULL ON HOARD OF FERARRIS

EARLY

IN THE

MORNING

RHYTHMIC

GYMNASTICS

LATE
WATCHING

11.22.63

DIRTY
DISHES
IN
A
DISHWASHER

SICK
SO
EASILY

STUCK
WATCHING
FRASIER

UP FOR FIVE HOURS ALREADY

SO BAD

CANCELLING

3
EXTRA
MONTHS

HAVE
REASONS
BEHIND
IT

THEY'RE PAID FOR

RUNNING
OUT OF

BECOME

A

SAUSAGE

ROLL

PERSONAL

PROJECT

BE
POOR
ANYWAY

BLANKET

SMELLS

LIKE

EVEN
DEEP
FRIES
FOOD?

THIS TIME EVERY YEAR

WHO DOESN'T LIKE GARLIC BREAD!?

SLIP

AND

CUT

NEVER IN
THE LIBRARY

WASN'T

EVEN

SPICY

AW
FUL
PER
SON

TOO

FAR

AWAY

OFF
GRID
SPOON
WHITTLER

DON'T MAKE AN EFFORT

BECAUSE HE'S KANYE

SICK

TO

DEATH

OF

PEOPLE

GOING
TO BE
DIFFICULT

NEVER EVEN FUCKING GOT THEM

THE MOST BITCHIEST, PESSIMISTIC PERSON EVER.

GETTI NG NOWH ERE

NOT GOOD ENOUGH

DOES
IT
REALLY
MATTER?

PASSIVE

AGGRESSIVE

SUCH

A

FUCKING

TIT

REALLY

ANGRY

TOO HUNGRY FOR THIS SHIT

www.ingramcontent.com/pod-product-compliance
Lightning Source LLC
Chambersburg PA
CBHW060854170526
45158CB00001B/355